ABSTRACT PATTERNS
MAGIC DOT
COLORING FOR ARTISTS

Illustrations by Tim Lawrence

Skyhorse Publishing

Skyhorse Publishing books may be purchased in bulk at special discounts for sales promotion, corporate gifts, fund-raising, or educational purposes. Special editions can also be created to specifications. For details, contact the Special Sales Department, Skyhorse Publishing, 307 West 36th Street, 11th Floor, New York, NY 10018 or info@skyhorsepublishing.com.

Skyhorse® and Skyhorse Publishing® are registered trademarks of Skyhorse Publishing, Inc.®, a Delaware corporation.

Visit our website at www.skyhorsepublishing.com.

10 9 8 7 6 5 4 3 2

Cover design by Jane Sheppard
Cover artwork by Tim Lawrence
Text by Chamois S. Holschuh

Print ISBN: 978-1-5107-1453-3

Printed in the United States

INTRODUCTION

We've all played connect-the-dots. You know, when you draw lines to connect seemingly random dots on a page. Usually, these puzzles also provide numbers by each dot to keep you on track with the image you're meant to create. You go from Dot 1 to Dot 2 to Dot 3 and so on until you have a picture of something like a bunny with a carrot or the Eiffel Tower. We've all wiled away the hours with coloring books as well—as children and as adults. Our masterpieces ranged from basic apple trees and cute cats to complex mandalas and artful landscapes.

Whether we're coloring or connecting dots, a great sense of fulfillment arises whenever we finish one of these activities. Completing creative tasks is an excellent stress reliever and brain exercise. This is because, in simple terms, we're using both sides of the brain: the left side works on the logical challenge of connecting lines to reveal a pattern while the right side flexes our imagination to select colors and see the final work in our mind's eye.

Abstract Patterns: Magic Dot Coloring for Artists is a combination dot-to-dot and coloring book—but with an extra twist. The dots don't have numbers! Why, you might ask? Because they don't need them! Each activity page features one completed module of a pattern. Just continue to repeat that configuration, and you'll reveal a stunning pattern of geometric shapes. Color the design to complete the page, and stand back to admire your work!

TIPS

- The front of the book features completed examples of each design. Use these for guidance as you tackle the dots or plan your color schemes.

- Dots are placed either where lines intersect or where lines bend and change direction.

- Every line segment between dots should be straight. You can use a ruler to help with this.

- Have fun!

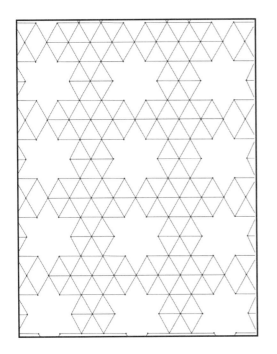

1

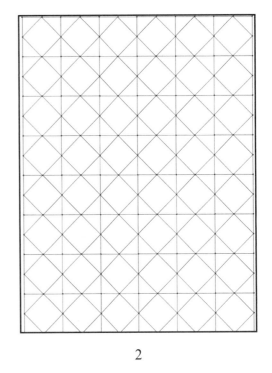

2

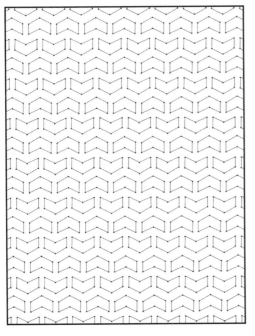

3

4

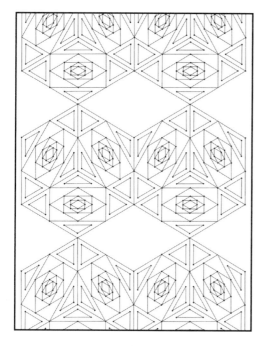

5

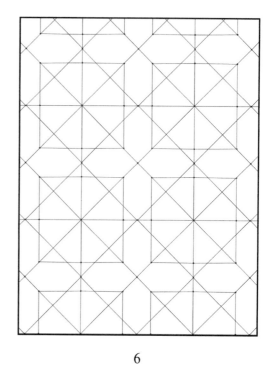

6

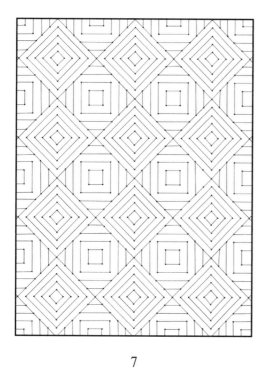

7

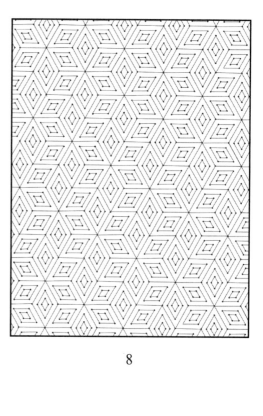

8

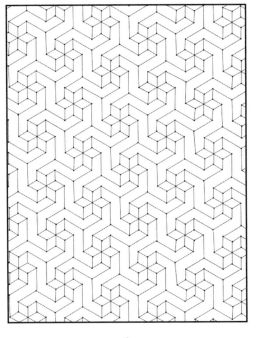

9

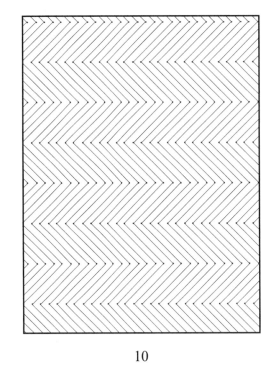

10

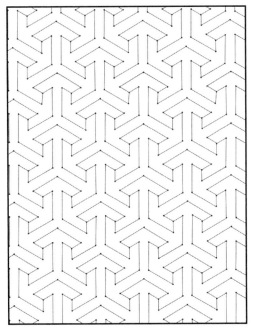

11

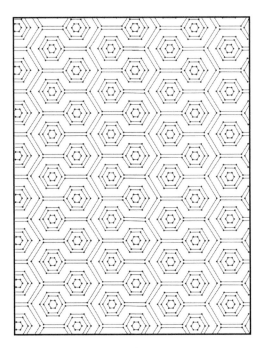

12

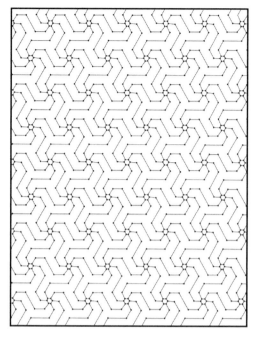

13

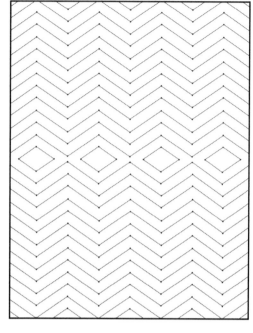

14

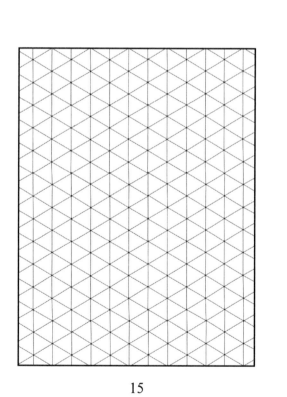

15

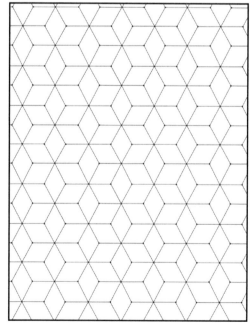

16

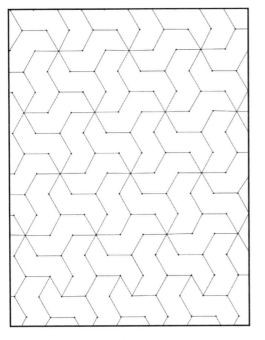

17

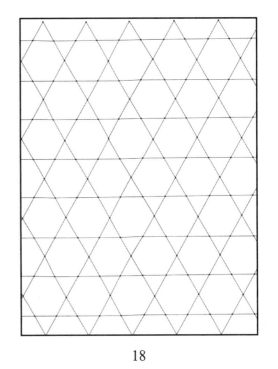

18

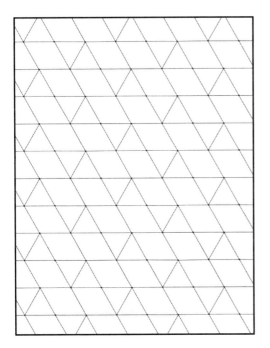

19

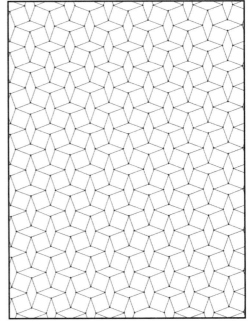

20

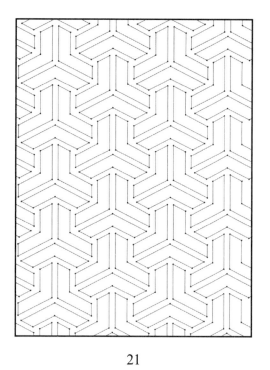

21

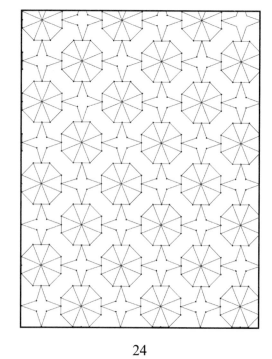

22

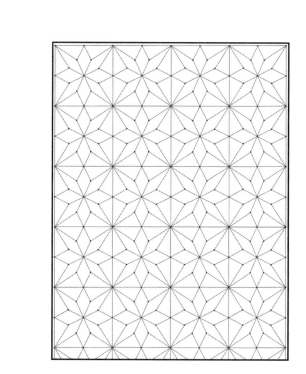

23

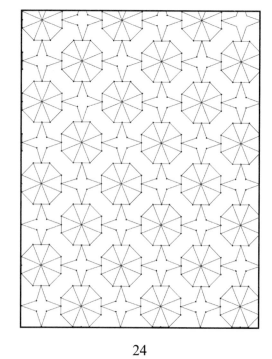

24

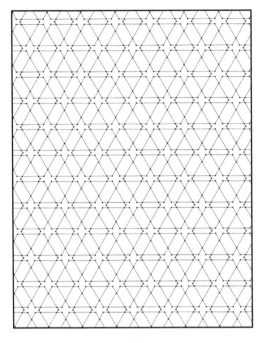

25

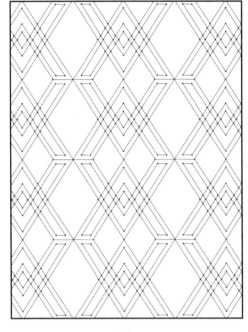

26

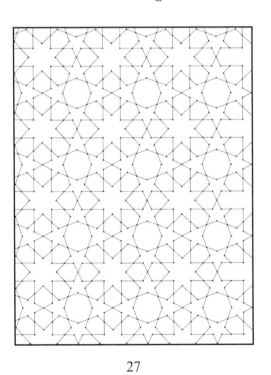

27

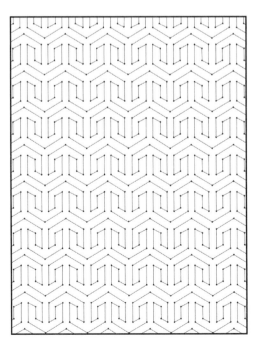

28

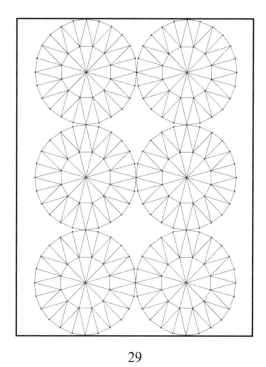

29

30

31

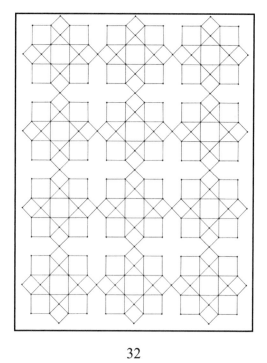

32

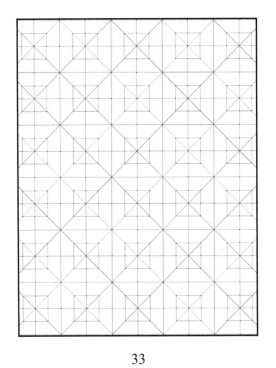

33

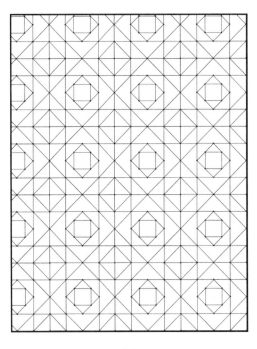

34

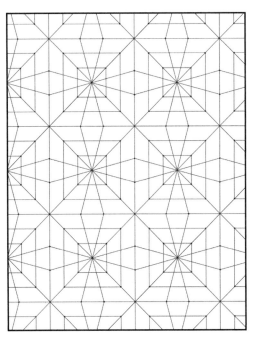

35

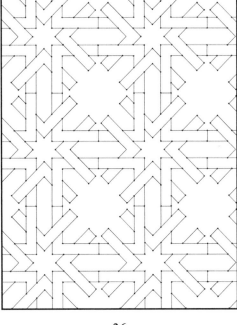

36

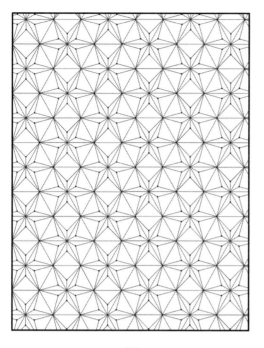

37

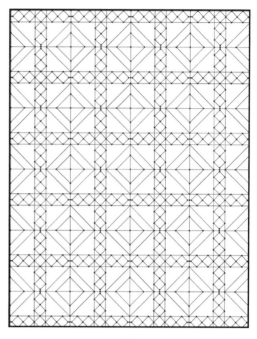

38

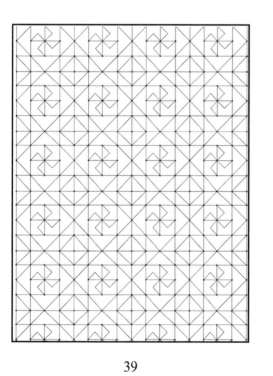

39

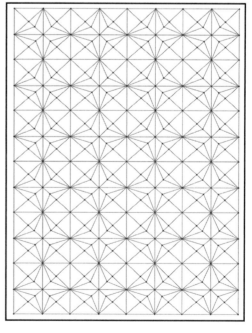

40

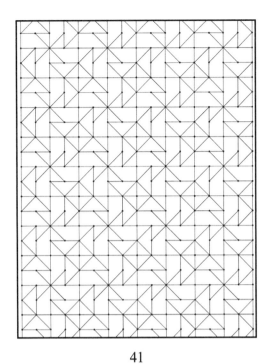

41

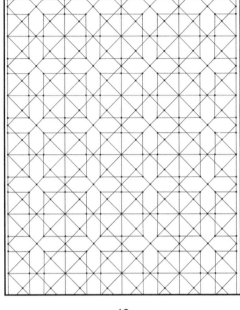

42

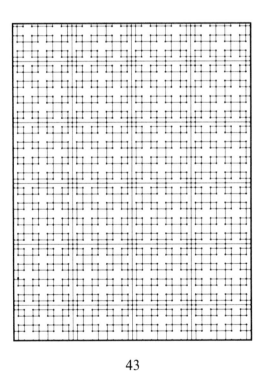

43

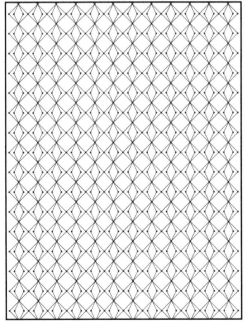

44

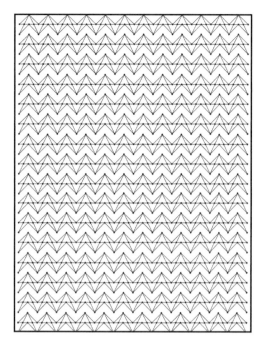

45

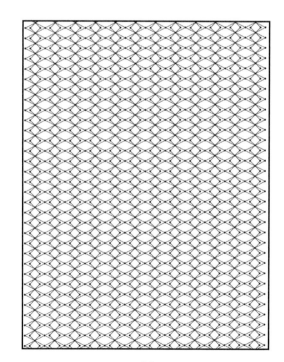

46

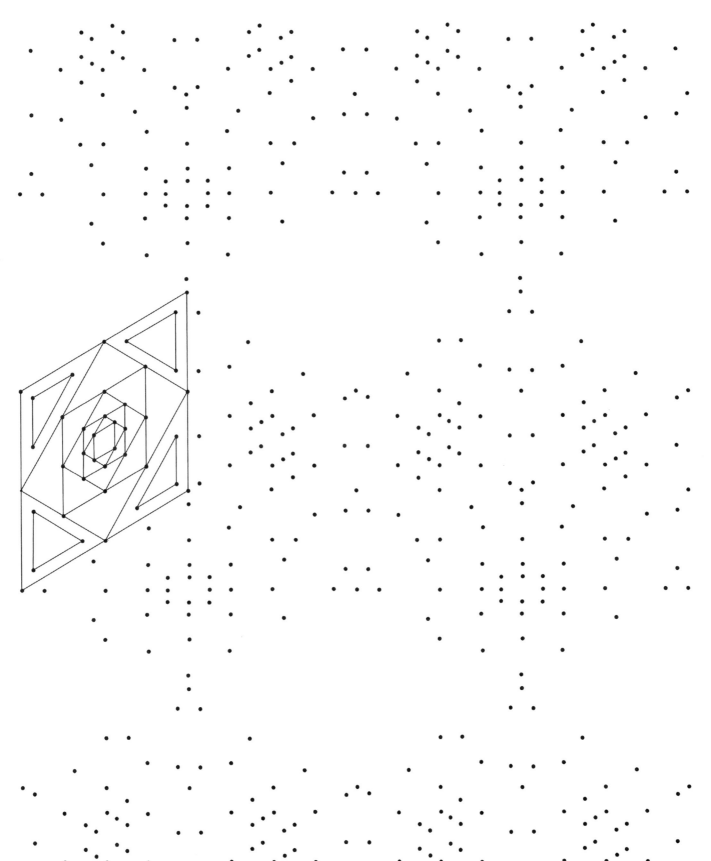

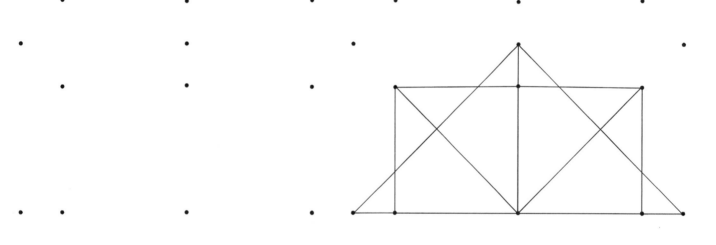

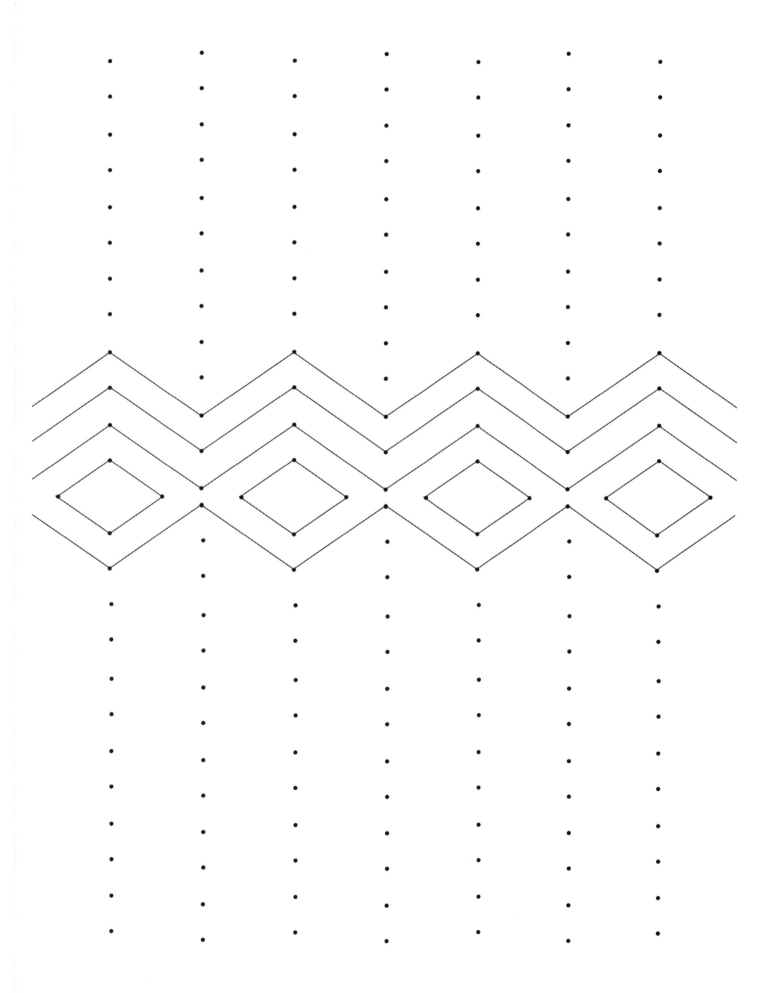

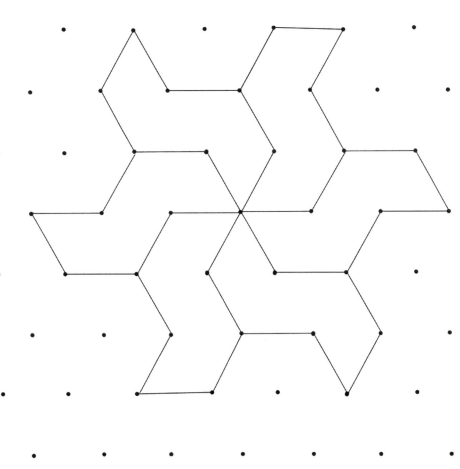

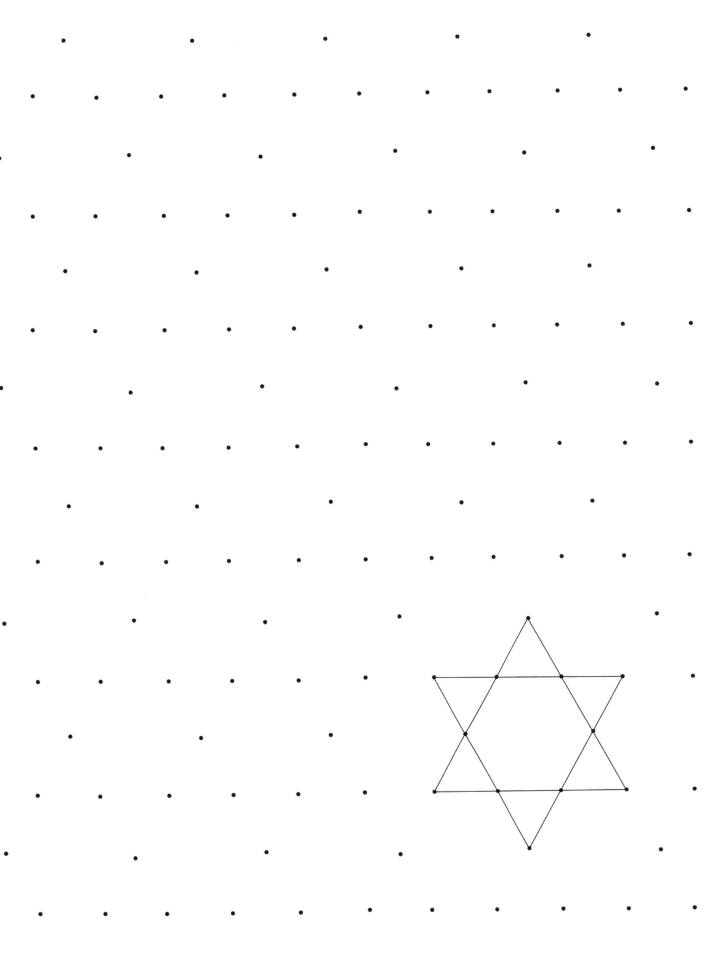

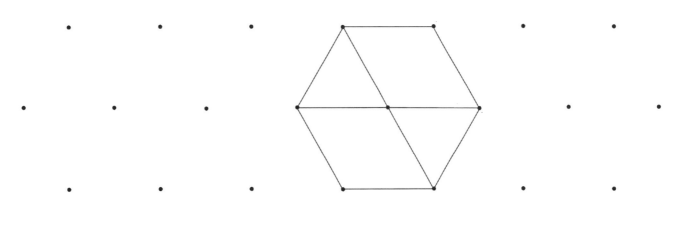

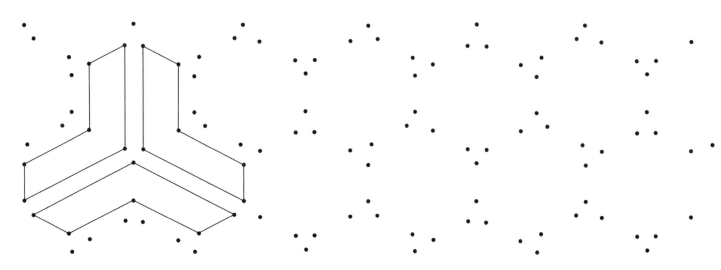

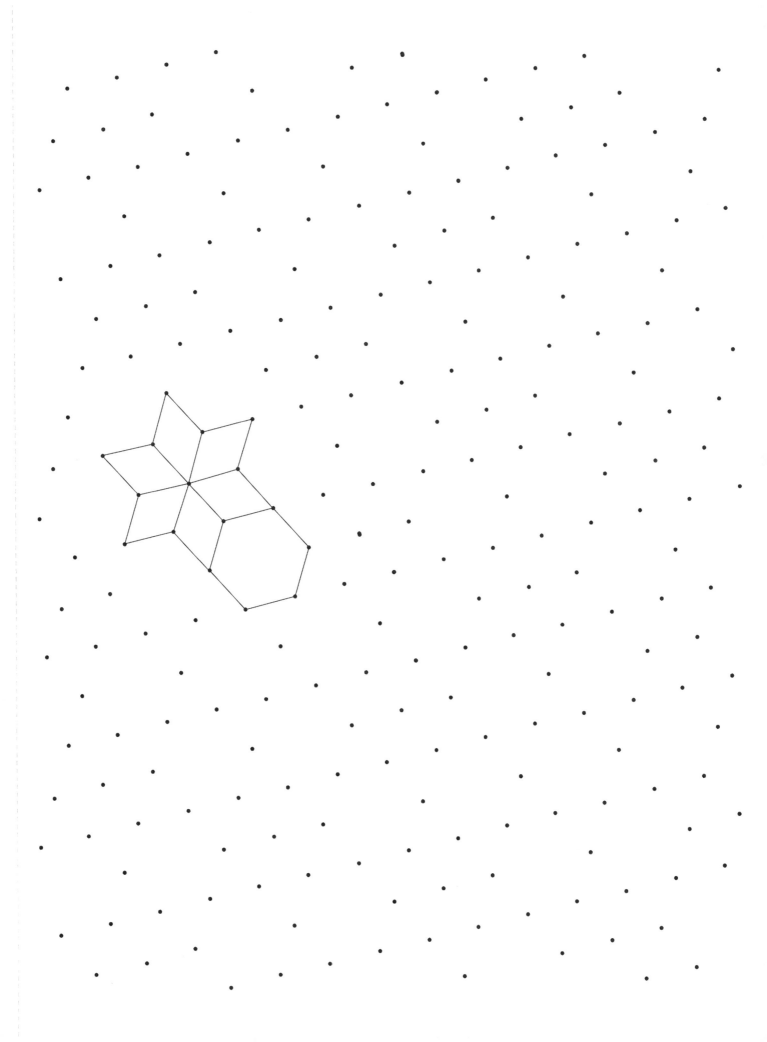

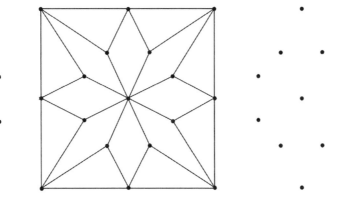

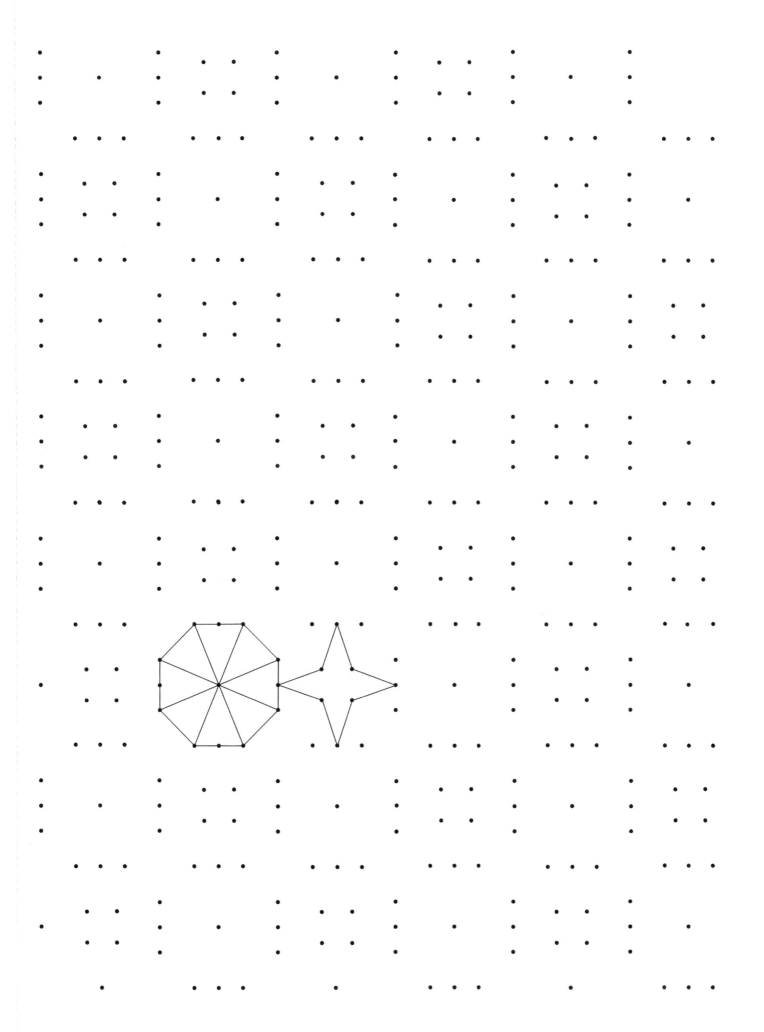

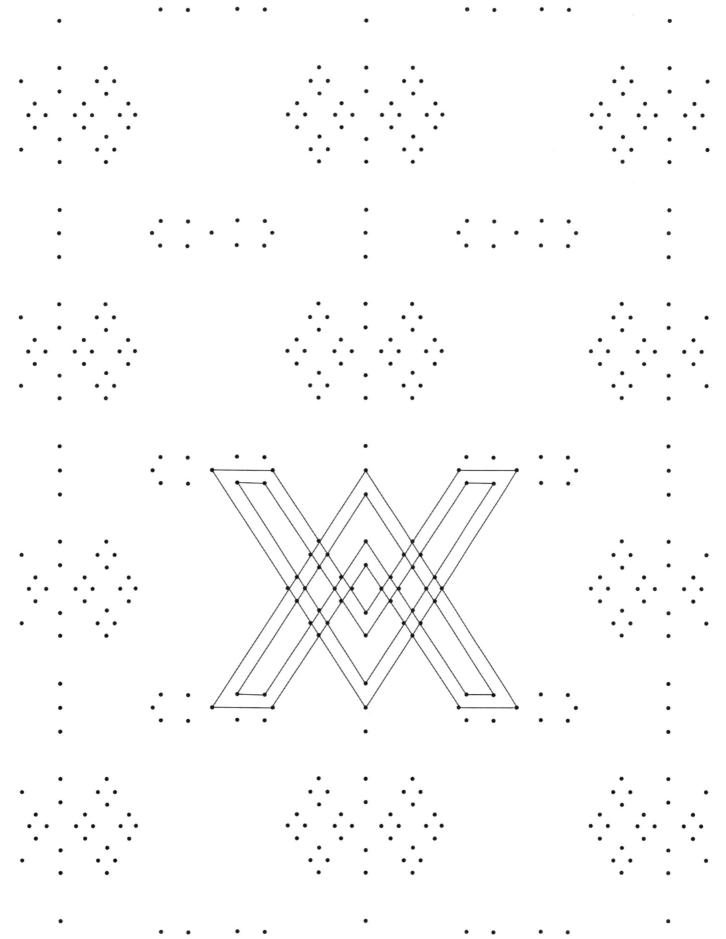

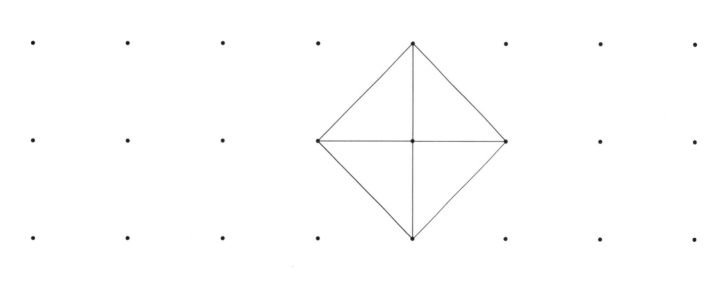

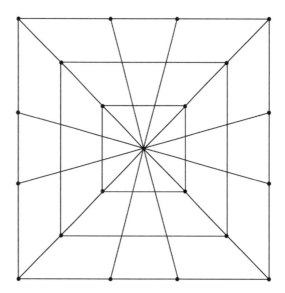

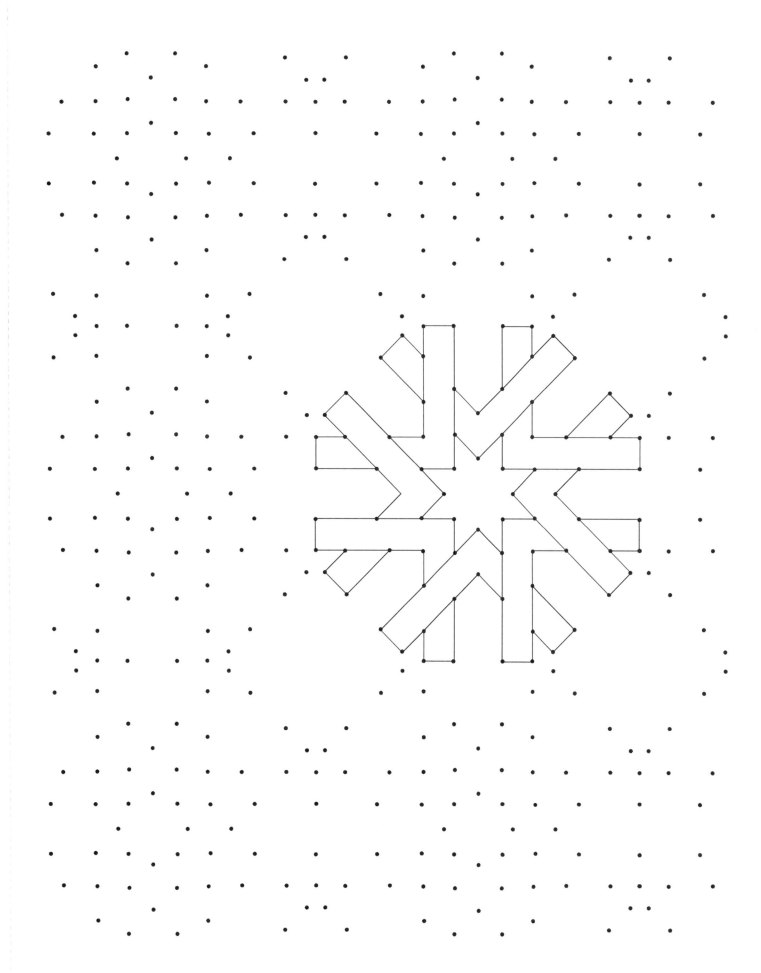

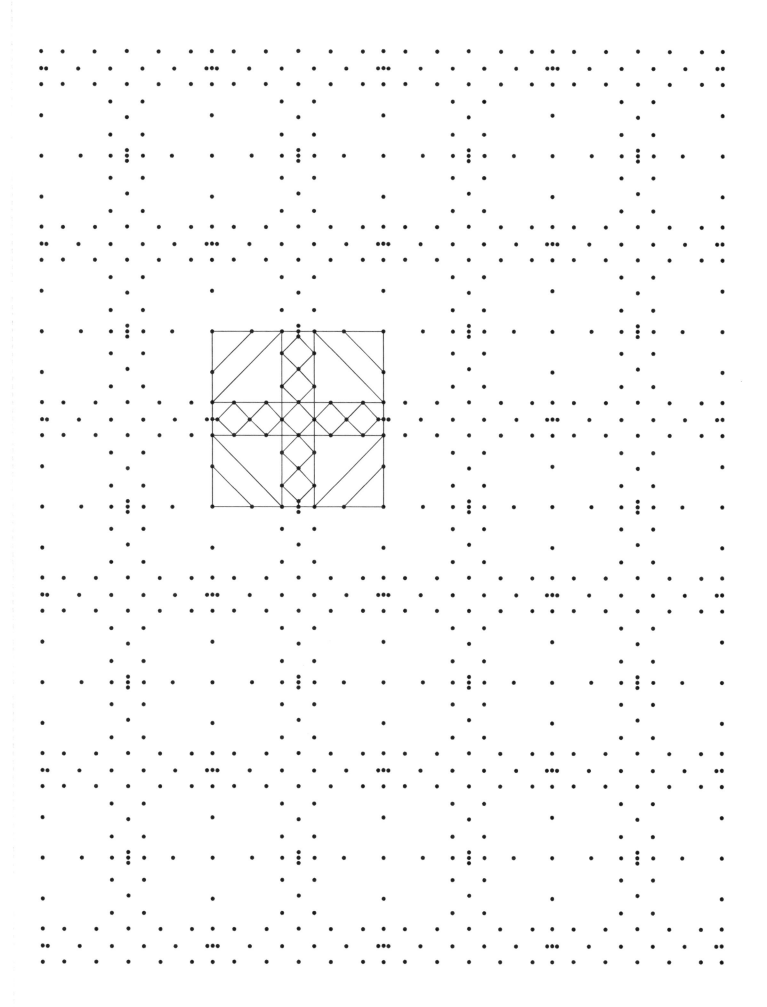

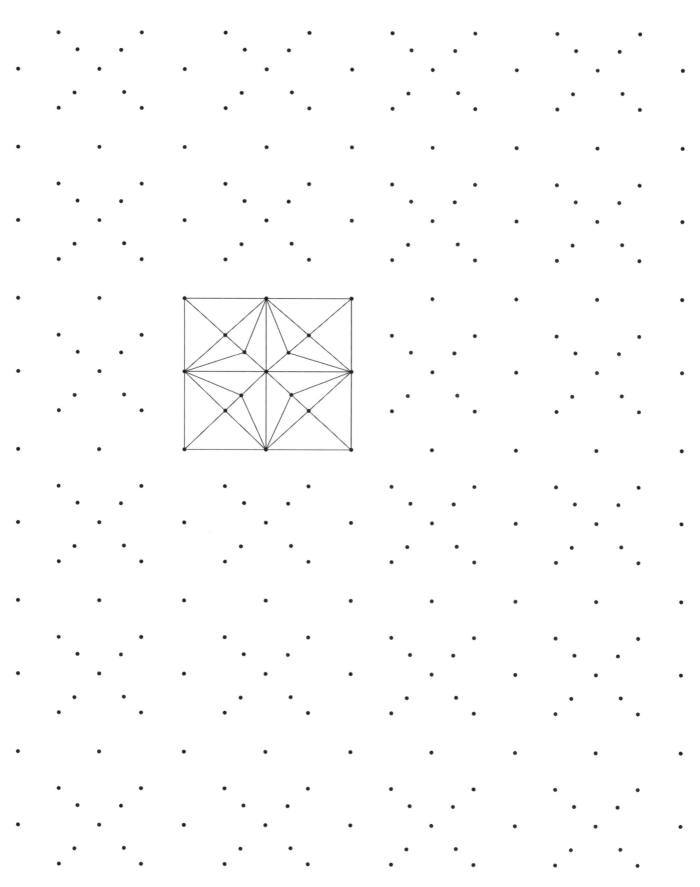

Palette Bars

Use these bars to test your coloring medium and palette. Don't be afraid to try unique color combinations!

Palette Bars

Use these bars to test your coloring medium and palette. Don't be afraid to try unique color combinations!

Palette Bars

Use these bars to test your coloring medium and palette. Don't be afraid to try unique color combinations!